No Longer Black And White

A Collection of Poems

By

Maria Christou

Copyright © 2019
All Rights Reserved.
ISBN: 9781080761678

Disclaimer

No part of this eBook can be transmitted or reproduced in any form including print, electronic, photocopying, scanning, mechanical or recording devices without prior written permission from the author.

While the thoughts expressed here are the authors own, any similarities and mention of sensitive events are not meant to be critical, harmful or derogatory in any manner.

Dedication

For

Michel and Kristia Lily who inspire me and make me so proud to be their Mummy.

And Garo

Your love has given me wings

Contents

Disclaimer	3
Dedication	4
Acknowledgements	9
About the Author	10
The Power and Beauty of Women	12
Our Boudicas and Queens	13
Steel Ballerinas	17
Burka	22
A Chameleon	26
Mistress	29
We Are Women	31
Your Princess	33
Mother	36
My Heart on a Sleeve	38
My A To Zee	39
Is It All In Vain?	41
If I Were	44

A Pallet Made For Me	47
Journey Over The Rainbow	49
That Moment	51
Our Ithaca	53
Last Kiss Goodnight	56
A Smile	58
Detox	61
Blue Moon	64
The Narcissist	67
Never a Pair Belong To Me	71
Love Truly	74
Love Orchid	76
My Ex	78
The World Through My Eyes	81
A Flame to Remember	82
Escape Without A Fin	87
Sleazy Cabaret	90
A Voice Attached	93

Responsible We All Are	97
Lechem, El Maa, Zait, Halas	99
Gods Worked In Disguise	102
Deliverance Angel	106
A Cover up Tale	108
Where Is Madeleine?	110
In Gods Eyes	114
As A King You Reign	116
From London to Jamaica	120
Art	122
Let Your Dive Begin	124
Friends and Family	126
Scuba Me!!!	127
Santa May Arrive	132
My Son	135
Single Dads	138
Always Hold Their Hand	141
Outsmarted By A Four Year Old	145

New Year	148
The Man, My Boy	151
Divorce & Friends	154
10 Years Old, Time For You To Know	156
Adopt In My Arms	160
Sand Yucky And Brown	162
Appendix	164
Sleazy Cabarat	164
A Voice Attached	164
A Flame to Remember	164
Responsible We All Are	165

Acknowledgements

Finally, to all those who have been a part of my journey and helped me get here.

It is because of their efforts and encouragement that I have a humble legacy to pass on to my children where one didn't exist before.

Thank you, first and foremost to my parents Andreas and Christalla Christou, Marianna Hadjiosif, Janice Ruffle Kavallares, Liora Bet Halahmi, the team at Content Development Pros for their editing services and last but not least, my rock, my base, Garo Zartarian.

About the Author

Born in London, Maria Christou is the child of Greek Cypriot parents who migrated from Cyprus to London. Her childhood was beautiful and she attributes her love and awareness of her roots to her parents.

She holds a BSc in Computing Information Systems and worked with an oil broker before she moved to the island of Cyprus 13 years ago.

Christou has faced various life challenges and turned to writing as an outlet. Poetry has always been her favourite medium to explore and she adopted it for her work.

As a lover of art and emerging artists, Christou has been active in the art community in Cyprus. She has been asked numerous times to write poems in support of various events and organizations such as for Women's

Entrepreneurship Day - WED and the Businesswoman of the Year Awards in Cyprus.

Christou has always been a warm, generous person and a loyal friend with friendships spanning over 40 years.

In her free time, she loves to go scuba diving. Initially terrified of water, she overcame her fear and has now become a qualified scuba diver.

She also teaches English online to Chinese students and loves spending quality time with her two wonderful kids.

The Power and Beauty of Women

To all the wonderful women in our lives!

The silent warriors;

Our unsung heroes.

Our Boudicas and Queens

These are the women
who pave the way,

Making their mark

For our daughters,

Our Boudicas and
Queens.

Their destiny;

To not be afraid.

A force to be reckoned with;

Determined obstacles

To conquer and overcome.

Leaders, excavators,

Their optimal mission;

To none they will succumb.

Their burdens, expectations,

Criteria, daughter, mother

And partner that they are.

Warrior strength, a requisite,

Juggling life's tightrope.

Masters, they've become.

Family, their ultimate reward.

She's the woman they adore;

A noble heroine, their Goddess

Magnificently balancing all.

Beware, these lionesses

Will lovingly purr

And protectively roar.

Synchronising, equipped;

For the heavy, leading ore.

Commander in Chief,

A mountain of obstacles

Rules that do not bend.

Breaking norms,

Resilient and victorious,

Gracefully,

These ladies ascend.

Support of fathers, husbands,

The male who has no qualms.

The woman with ambition,

Advocators today, tomorrow,

Before you, together

They stand as one.

Contagious energy

And inner mental strength.

Refined beauty, united

Their Alpha wavelength.

Modern emancipators,

Far from amateur;

Backbone oozing confidence,

We salute and celebrate

These businesswomen,

And female entrepreneurs.

Steel Ballerinas

Migrant Woman!

Unique story she tells.

Begins with pain, like many;

A different kind of hell.

This woman stopped dreaming,

Reality taught her that.

No warm welcome,

Blunt confirmation,

Daily reminder,

To never lose track.

Labels attached.

As if, her deal in life

Wasn't bad enough.

Don't rob her of her dignity.

For she'll surprise

With her fight back!

Her unequivocal determination

Is what keeps her strong.

So many rely on her,

Sacrificing for them

And at some point,

Silently, scraping along.

Determined, she'll work

For her break in life!

Proving she's capable

And how she truly, shines bright!

Don't underestimate

The migrant woman

Who knows her worth!

She's a thunderous force

Unnoticed at first.

A protective guard she'll wear,

Heart bleeding to God

To hear her prayer.

Keeping her promise;

Heavy, her shoulders

The weight she must bear.

A better tomorrow!

Constant memory, Motherland.

Her drive, source of ambition,

Duty, her life, reassigned and defined.

Rationale of "why?" and "what?"

Brought her here.

Leaving the seasons she grew up with far behind.

These women are soldiers,

In civilian clothes,

Marching daily amongst us;

Beautiful and stunning;

Pirouetting through Life's

Turbulent woes.

So, stand and applaud!

Steel, backbone ballerinas

With their tormented, hidden

Cuts and bruised toes.

Burka

The Burka;

Invincible bars to eyes.

Sadness, oppression,

All disguised.

A culture born into;

A lifetime to bear.

Choice or force?

Who actually cares?

Assumptions we make.

Stop, think.

These ladies ache.

Where in the Quran

Does it state?

Ulama or Scholars

Agreed upon.

Interpreted, as men do.

Their ego to women

Inflicted upon.

Fashion Police

They have.

"Hadith"

And "Scholars of Islam."

Misquoting verses,

Commandment for hijab.

Respect the Quran,

Yet explain.

'Peace upon you'

'Purgatory'

Hand in hand;

Inexplicable pain.

Rule and demand.

A loving

Father, brother,

Husband may have.

Surely, today

Walk in a street

No cause for riot,

Freedom of speech.

Jailed for life.

Interpretations

Incorrectly preached.

These sisters and women

Liberation they seek!

A Chameleon

A woman, her *'tragic'*
story she tells;

Selective information.

A chameleon.

Silent alarm bells!

Damsel in distress,

To play on your softer side.

Convinced; from all her lies

That she hides.

A non-team player;

Disgracing, letting

The female side down.

Slandering, those ladies;

Who fought with dignity.

To stand proud.

Abuse, her blessed,

God given right.

'Mother,' her sacred title

She uses in spite.

Queen; adored she'll be;

If justly, ethically

She acts honourably.

Irreversible damage;

If she does not take heed.

Disastrous outcome,

Her price to pay;

Permanently.

Mistress

Like an addiction

Men love her too.

Giving her a name

That they choose.

Each have their favourite kind;

A personal choice

To blow their mind.

Some are small,

Others large;

Whichever kind

Captures their heart.

Hours, fulfilling their secret need.

Protective and attentive, they will be.

Their mistress and escape.

Amateurs; she will never take.

Together, they will travel;

Sunsets, they will see.

A drug, an injection;

Total therapy.

Flaunting their love; shamelessly.

The one and only,

Their yacht, she will be.

We Are Women

Dynamic, intelligent, yet static and mediocre; if you bore her.

Multidimensional, complex and complicated, yet flat line and deaf; if you cannot take heed.

Full bodied and vibrant yet will drink alone; rather than the awful taste of bad company; as will not condone.

Stunning and beautiful; our individuality far from stereotypes and superficiality.

Loving and caring; her nurturing side can be, but will slam the door if ever tampered, abused.

..... just try, if you do not believe.

Because, we only as one can be. Never misuse we are "Women". Without us, a nobody you will be!

Your Princess

I try to remember

What it was like.

I try to image why her demands;

So strongly expressed,

With such innocence,

Pure as the night.

Listen to her,

When she wants

To hold you tight!

Indulge her, regardless

Of how tired you may feel at night.

There's a reason we may not understand...

Maybe, she simply just wants to hold your hand.

Security of knowing you are there,

During her sleep.

Lack of control, fully aware;

Her love for you,

Oh so deep!

You, on the other hand,

See something so unique.

Watching her breathing

And contentment.

Like an angel, she sleeps.

One day, a woman she will be.

So, for now, hold her tight.

As always

Your Princess is she.

Mother

She gave birth to you;

Her sacrifices untrue.

She loved you,

Before God.

She'd die for you!

She smiled and laughed.

Her pain never exposed,

Before you.

She cooked;

A memory of smell,

Only for you.

She worked with passion;

To provide for you.

She didn't sleep;

Her worries,

So you never had to.

She, the Lady;

Her pedestal,

Humble to you.

She, your Mother;

You'll always measure the lady

Sitting beside you to.

My Heart on a Sleeve

My feelings and emotions;

Caught in a net.

Finally set free

My A To Zee

You are my 'A' my
'Zee'

You are all

The in between.

Brighter, my world;

Now that you

In it I see.

No longer black and white.

Now, colour

Variations,

A natural delight.

Even when it's dark

Your aura shines so bright.

My hope, my miracle,

To my heart's

Forgotten plight.

I love you, my darling.

In my arms, sleep blissful,

Night after night,

Is It All In Vain?

The pain of the world
etched on your face;

Trying so hard not to
fall from grace.

Each line and wrinkle
has a story to tell.

Yet, deafened by ignorance,

Of a once caring world.

A battle within, strikes every day.

Torment invades; a slow decay.

Injustice keeps you awake;

The anguish of someone else's wake.

Defeat cannot be consumed.

Revolt at a people, adding to your wound.

Chained to your thoughts, as a slave to the oar;

A barbaric infliction, yet you see no shore.

Determined true, to your heart;

A masochist to your beliefs.

Alas, of which, you will never part.

A compulsive disorder is your trait.

Ambitious in goal;

For change of a world, you cannot escape.

How will you convert a land of pain?

Who will hear your heart, your voice?

Is it all in vain?

If I Were

If I were a mouse;

I'd run and hide.

If I were a cat;

I'd purr

And feel content inside.

If I were a lion;

I'd rule the pride

If I were an eagle;

I'd swoop and glide.

If I were a dolphin;

I'd swim worldwide.

If I were a butterfly;

I'd fly freely till I die.

I am a human;

A species of a different kind.

In so many ways;

One of a kind.

Searching for purity,

Only animals,

Instinctively find.

I am, who I am.

I'll make a difference

To my world;

In this lifetime!

A Pallet Made For Me

No need to close my eyes,

to see

Each line on your face,

Your forehead

All so precious to me.

Your touch, your movements;

Gestures invisible,

Yet, not to me.

Blind, before me,

They have been.

To colours only, I can see.

Endless shades;

A pallet made for me.

Priceless rainbow;

Unique treasure,

You are to me!

The masterpiece I see,

Is that of you.

Safely stored, protected;

My heart's crown jewel.

Journey Over The Rainbow

Gut instinct

Never proven wrong;

A torture it is.

Never allowed,

To hope or dream on.

A rainbow appears;

Your colours it displays.

The end of it,

Predetermined,

You believe it will be grey.

Unconvinced, try.

Learn to become;

Teach your mind

Possibilities,

Enjoy the rays of sun.

Your journey over the rainbow,

Surprised, you may be,

Never wrong were you;

Until the time,

You met me.

That Moment

That moment was mine

And mine alone.

My tranquil escape;

To the world,

That I know.

Underwater, when I dive,

Body and soul;

Imagination alive.

Ballerina, I could be;

Swimming with fish.

Pirouette.

If you could only see me!

Summersault, and round I go;

Arms flowing,

Sea life, enjoying the show.

Time lapse;

How long, I don't know.

Treasured memory;

Till the next time I go.

Our Ithaca

Life, never simple;

A word, an expression

Changes all.

What's needed?

Understanding,

That's all.

A highway, no exits;

Ignorance I'm jealous of.

No options, decisions.

One way,

Cruise control, on.

Crucifying it can be,

When you can see

What's meant to be.

Yet intelligence; often

The biggest enemy.

I still believe;

Truth and honesty,

However cruel,

It can sometimes be.

At first glance I knew;

When I met you.

Last chance of finding,

All I had aspired to.

Take the exit;

Leading to me

On the highway,

Of our beautiful destiny.

Don't travel alone;

Pause if you must.

Refuel and reset;

Destination? Please trust.

Our Ithaca,

Is ALL that you ask.

Your heart for once;

You must trust....

Last Kiss Goodnight

How did you say goodbye?

Invisible your wings,

That made you fly.

Why did you leave?

Did you not hear them cry?

This is not,

your time to die.

Lost in a daze of pain;

Those you left behind.

Visit their dreams

And hold them tight.

Whisper gently;

To ease their fright.

For they will never

Have you, in their sight.

Are you smiling there, up high?

Help them come back,

For one last kiss,

Goodnight.

A Smile

A smile.

What does it say?

Diverse; for so many

Meanings, never the same.

A smile, to a child,

Can raise them to the sky.

A smile, in return,

You will carry;

Till you die.

A smile, to a stranger,

Crossing the street;

Can make their day.

Knowing again,

You will never meet.

A smile, to your dog,

Will perk his ears up high!

He will know,

How you feel inside.

A smile, at work,

Will ease the stress.

Colleagues and bosses,

Problems will hurt much less.

A smile, to your love,

Says so many words.

A new lease of life;

hope, and natural returns.

A smile a day;

A natural vitamin A.

So, pay attention;

Start living and share,

Your smile today!

Detox

A detox, they say;

To flush away,

All toxins and body weight.

To begin on a Monday.

A flat tummy;

Is guaranteed

By drinking gallons of water,

And herbal teas.

Pineapples, apples,

And various fruits.

Yucky concoctions;

A pallet to seduce.

Miracle diets, posted every day.

Claiming; easy and simple ways.

Selling hope, to new recruits.

People, like me, are target groups.

Dream of delicious food.

Memories of vino too.

Indulgence of chocolate mousse;

All to be, "out of use."

Bikini day; not far away.

"Hang in there" is what to say.

Beach body will not come free;

No choice,

So detox it must be!

Blue Moon

Tonight,

I'll wait to see,

How blue it will be.

Don't sleep.

Three years;

The next will be.

A phenomenon,

From out of space.

A lesson for all;

Go love!

Capture, embrace!

The moon, shining;

What's it trying

To teach me?

Don't be scared.

Trust in

Your soul,

And all its energy.

I'll do it.

I'll think of me.

For once;

My dream,

My heart,

No longer

Blue, will it be.

The Narcissist

A dictionary of words;

Yet one is obsolete.

'Sorry' to the narcissist;

Incomprehensibly damned.

Life, sad

And incomplete.

Articles and definitions

Of who and what they are.

Wrath of tyrant vanity,

Possessed, extreme

And pitifully bizarre.

Dictators of thoughts;

Shield no one.

The closer you are,

Obey and compliment.

'The superstar' image;

Their ongoing facade.

Their dangerous web of lies;

Never a blink of conscience,

Always justified.

Destroy and desecrate;

Useless now are,

Their ongoing

Victims lives and sakes.

The world owes them ALL!

Self love, reflected

In their pool.

Toxic traps set.

The tragic, next!

Yet, unbeknown fool.

Beware of their disguise.

Garden of Eden; powerful, natural,

As Gods, they entice.

Invisible, small print;

Don't enter!

Ultimate outcome;

Guaranteed,

Is your demise!

Protect and defend yourself!

Their demons, glamorised.

A martyr, don't become.

Freud's theory there;

To read and open

Your eyes!!!

Never a Pair Belong To Me

It's a wonderful feeling;

Helping others who need.

Shush, a secret,

I plead!

Self ego, caressed.

It's true!

Try our best,

We will always do.

Yet, deep inside,

Full of pride;

Ourselves, always

Cast aside.

Never a favour to ask.

Camouflaged mask;

Only to see,

Wings around me,

Yet never a pair

Belong to me!

Rejection; gloss over.

We cannot do.

Dare is something

For others,

We happily pursue.

Fear.

No excuses;

Only bitter truth.

So carry on helping,

Till someone helps you!

Love Truly

'Love Truly'

Not many can do.

When you find it,

Embrace it;

Destiny, before you.

All masks out of sight.

Courage needed.

Cherish;

Your exclusive right.

Respect and treat it right;

Give back; wholeheartedly.

Rare chance

In Life's plight.

When it blooms,

In your sight;

Breathtaking gasp,

With delight!

'Love Truly', raw,

With no disguise.

Hero to your soul;

Two hearts.

Your once in a lifetime;

Ultimate prize.

Love Orchid

Orchid, a flower, some may see.

Orchid, far more, to you and me.

As I admire you;

Graceful, elegant and tall.

Protect, no harm

On you to befall.

For, we will grow;

However hard the rain.

Together, bloom

Feel no pain.

Love, orchid,

In our hearts

Will reign.

Survive all seasons.

Passion watered;

Our secret champagne.

My Ex

You may be my ex,

But someone I'd never forget.

16 years, of highs and lows;

Stuck together through Life's many blows.

You were my husband,

And always my friend;

A man I'll be proud of,

Time and time again.

A blessing of two children;

A bond that will never end.

Always their Father.

Grateful; from you, they stemmed.

We tangoed to beat, for many years.

We laughed and shed a few tears.

Mutual support; our highs and lows,

Developed and watched one another grow.

In time, we drifted away;

Our course in Life had a different DNA.

Mature enough to see,

Hypocrites; we will never be.

Agreed together to part,

And go our own ways.

Dignified and graceful;

We were never clichés

No sadness today;

As we care too deep.

Wishing happiness;

As we take our next leap.

A parting, not many
will comprehend.

Yet you and I know;

We will always be best
friends.

The World Through My Eyes

Take a look through the looking glass,

At what troubles we face.

Yet, hope springs up;

With each new day

A Flame to Remember

"*Box on the ear*" was the trigger,

For what was to come.

Abdul Hamid the Second,

Monomaniacal Sultan.

Armenian existence and so,

The murders begun…

Simply by,

The tapping of his thumb.

"*Young Turks*" the devils spawn

Overthrew, and

Ottoman Sultan was out.

Official date, 24th April 1915

Scholars, academics executed,

Fate set.

Genocide;

Never to be undone.

"Killing Squads", "Butcher Battalions"

Drowning, crucifying and burning alive.

Armenian corpses, more than animals,

Lay across the countryside.

Raped, naked, in the desert,

Under the blazing sun.

No bread or water.

They dropped, one by one.

A stop to rest was met

With only one outcome;

Shot, bleeding, vultures fed on.

Crime of existence

If your name ended

Simply with… "ian"

Children kidnapped, forced all who remained alive,

Convert to Islam.

To save you

And your children's lives.

Mothers, daughters; assaulted,

Violated and assigned,

To Harem hell.

Slaves, to the tyrant tormentor.

Broken, their hearts drowned

In tears,

For being their infidel.

Armenian; an epochal people.

GENOCIDE; Turkey to admit.

1.5 million – a crime.

Mass slaughter, a fact, modern history

To recognise and never forget.

Justice still waiting to be served.

Descendants, forefathers gone.

Their memory, unequivocally preserved.

Armenians will fight,

Mourning their dead

Voices to be heard.

Generations of souls.

Solemn prayer, a flame to remember

With each candle they light.

Bowing heads, condole

Their story, deprived and stripped

Their fundamental human rights.

Escape Without A Fin

When I lay in the
water,

Submerged within.

My ears are covered;

Escape,

Without a fin.

All I hear,

Is the sound of my breath.

My mind, for a moment,

Allowed to rest.

Slowly, I focus

On the sound of my heart.

Tranquil at peace;

Water...

My answer;

My restart.

There it is;

A time away.

A few seconds, maybe.

Yet heals

Traumas of the day.

Afloat and enjoy,

That moment is yours.

Close your eyes,

To all of Life's chores.

The ocean; with you

Has no wars.

Sleazy Cabaret

'Imagine' John Lennon

Would sing.

'Hope,' now painful,

As a bee sting.

'I have a dream'

Speech of

Martin Luther King.

An obsolete thing.

Malcolm X spoke of *'justice,'*

No longer a common practice.

Gandhi that of *'conscience.'*

Now, full of absence.

'The sweet roots of education' Aristotle, to quote.

No longer an option;

Surrounded by demand note.

'...ask what you can do for your country' Kennedy famously said.

Critics we've all become,

A quality now dead.

Who are the heroes of today?

To inspire change for a better day?

What will history books say?

Surrounded by foul play,

All led astray.

Required to pre pay,

The world a sleazy cabaret.

A Voice Attached

Oppression - a word

Tragically, often used.

Surfing the web,

Newspapers and TV news.

Posts and quotes

Of the greats we make.

Do we take the time,

To read the words,

These heroes

Suffered to state?

International Court of Justice.

Ultimately to rule upon,

A stigma attached

To history, long gone.

Genocide and crimes

Against humanity;

Some condemned,

Others dismissed,

Corpses not enough;

Convinced,

For the world to be.

Movies are made.

Gandhi, his name,

Children not knowing;

Alas! his teachings,

Die in vain.

Open eyes

To what he said.

Profound statements,

Should never,

Be put to bed.

Tyrants, dictators,

He spoke of.

Terrified masses

Suppression of freedom,

Strength, hope

To act upon.

Lessons for governments today.

Demand subjects,

Each person has a name.

A voice attached.

Citizens shout out!

Don't stand alone!

To rights as humans,

We all own.

Responsible We All Are

My heart aches.

My heart breaks.

Children's bodies.

Mothers risking;

Incomprehensible stakes.

Like sea shells;

Scattered, they are.

God, turning away.

Gone to reign

Some other planet, afar.

Disgusted in who we are;

The world, we share.

Calculating cost;

Can't afford to help

...they're always just,

A little too far.

Who will mourn,

Those innocent,

Lost, sea stars?

Whose conscience,

Bears the scars?

Bow our heads;

Responsible, we ALL are!

Lechem, El Maa, Zait, Halas

Bread, *lechem.*

Water, *el maa.*

Olive oil, *zait.*

Grain of salt, *halas.*

Symbolic; you will find

Survival, through,

The ages of time.

From Hebrew, Egyptian,

Arabic and Greek too.

All common and sacred.

Beliefs;

Entwined they do.

"You will not eat lechem by the sweat of your brow."

Garden of Eden;

Adam did bow.

Gods of the Nile;

A river, a centre between,

Life and death, 'el maa.'

Worshipped.

Afterlife;

Forever clean.

Arabs, 'zait' did press,

And introduce

This virgin, healing,

Miracle juice.

'Halas' preserved and sprinkled;

Seasoning believers, as they grow,

The Greeks would trade;

Ancient commodity.

Today; 'salt,'

We all know.

Common to each
table they are;

Ingredients,

For living,

All under one star.

Gods Worked In Disguise

That time arrived;

In a blink of an eye.

Without seeking,

The Gods worked

In disguise.

Those years of pain;

Eventually, you mastered.

Your life, you regained.

Settled and content;

Expectations repelled against.

Never again, you vowed

Adamant and in control.

Anguish before God;

You bowed and promised

No longer to behold.

A tsunami of pain, you convicted him

And all those who attempted after he.

Poison to your heart;

The only antidote: stay away.

For your sanity and sanctuary.

Almost a miracle, that fell from the sky.

Rainbows alive, music in your veins;

Joyous angels, passion never lived.

Breath of life; no longer living in vain.

Wild seahorses, jumping hurdles.

A vibrant mermaid, heartbeat racing.

The reins you hold onto.

Resuscitated, awake,

Embracing life; you celebrate.

Conversations with eyes;

Laughter of thoughts.

Lovemaking devotion,

Sunshine to starry candlelight

And homemade erotic sauce.

Allow Life's course,

Travel this captivating, amazing, flight.

He's your hero;

Your modern day

White knight.

Enjoy these new heights with delight,

As tomorrow, will always be bright.

No longer the limbo,

Of that dreaded twilight.

Deliverance Angel

Rock bottom - a bitter taste.

The world - unable to face.

Bleak, desolate,

Black, tormenting cloud;

Wrapped within

The burial shroud.

Suffocating, choking;

Each breath a struggle

To be found.

Enveloping all;

Screaming within,

A hellish, screeching sound.

Deliverance – the angel;

Miraculous fracture,

a beaming light.

Forceful energy;

Benediction – a divinity.

Salvation – in sight.

Final moment;

Freed from pain.

Clarity illuminates,

Euphoric and blissful.

Glorious future, once again.

A Cover up Tale

Liars, liars both of they;

Convincingly, fooling

For years, but not today!

Conspired a story;

A cover up tale.

Dressed with deceit;

So no one can tell.

Bitter and sad;

Easy to be.

Wasted years believing,

It was meant to be.

Dying to say,

"Go to hell!"

No longer captivated

By the faux spell.

Time squandered

But learn to see.

Less is more; burned again

Never to be.

Sacred and pure,

The next time round.

Genuine happiness;

Deserving joy

To be found.

Where Is Madeleine?

Where is Madeleine?

The world still seeks.

Since 2007;

The media still speaks.

Horrendous it was;

The fear all parents.

Nightmare of…

Conspiracies – exasperated;

No stone left unturned.

What of the children

That all look alike?

"Only a mother"

Random line.

Given the chance;

Blindfolded,

She will find.

Black, African;

Children lost.

Thousands gone missing

Yet unheard of.

Names too long;

To pronounce.

On front page headlines

Who cares

To announce?

Numbers — a rating game.

News channels.

International war;

Agenda.

All the same.

Books — published.

The best seller rack;

Guaranteed of.

Green eyes, unique;

The colour of money.

Exploiting emotions

Goal, they seek.

Knowing full well,

Light is bleak.

Brown eyed, no chance;

Even one to find.

Hope for tears;

Evaporated.

Plea declined.

In Gods Eyes

In Gods eyes,

All the same

In His name, pray we do.

Never treat my children,

Different – criminal to do.

No favourites; from my

Bosom they came,

Cherish them,

I do.

How is it then,

God allows us, to?

Some go hungry;

Whilst others bellies,

Blissfully full?

Have faith, all taught,

Believe, we must do.

But where are you?

Our Saviour?

When starving in

Your name cry out

So many do?

As A King You Reign

Cast a spell on those that encounter you.

Your interests are far from few.

Master in all you do;

Humble,

Is a speciality for you.

Your trademark, compassion,

Sets you apart.

A silent passion,

Waiting in the dark.

Only you know when

It's time to outsmart.

Patient yet intimidating;

If you choose to be.

Forgive, chances given.

Ultimately end at three.

Knowledge – from you to gain.

Debonair with your unique flare.

You decide, command;

With whom...

And what to share.

A Royal aura.

As a King, you reign;

Men admire, you in vain.

Alas! A gift they strive

Yet cannot gain.

Mere mortals, by command,

Move on cue.

Willing and submissive;

They do it for you.

This Leadership gift,

Bequeathed to you.

A magnet to all;

Capture you do.

Awaiting acknowledgement,

Only from you.

Monochrome fools will see;

Infected by ignorance,

Of jealousy.

What technicolour rainbows;

Intelligence and knowledge

Can achieve?

From London to Jamaica

From London to Jamaica,

Paris, Rome and Vegas too

Places I have travelled;

Judging if indeed,

Too good to be true.

The Far East, I'd like to go.

To see new people,

And their cultural show.

How wonderful to add,

To a list, of where I have been.

Australia, so vast;

History of the Aborigine.

So I may grow, and prove,

In a crowded scene,

How educated and diverse

my opinions, all to envy me.

How small the above

Is ultimately,

When your heart is fulfilled,

By home; wherever

That may be...

Art

Why do I love art so much?

Is it what I see?

What senses a piece,

Evokes within me?

I love the abstract,

Contemporary kind.

No borders, restrictions;

Sight driving the mind.

I don't want a story,

Defined before me.

Art is what,

Only my eyes can see.

Exclusive secret;

Belonging only to me.

Euphoric discovery,

Symphonic silence;

Quietly free.

Let Your Dive Begin

The most healing thing,

For me;

Underwater to be.

Therapy; each dive will be.

Never disappoints me.

Never alone,

My buddies;

My underwater backbone.

A team to dive with,

Protect, ensure

Safety;

The Zenobia wreck to explore.

Beautiful to see,

So many like me.

Addiction bug;

Contagious.

A different world to see.

Crashing water sound.

As you jump in;

Trigger adrenaline.

Let your dive begin!

Friends and Family

They bring out the best in us.

Our playful side,

They emphasize.

Gratitude and love to all.

Scuba Me!!!

For years, the water frightened me,

Even the tranquillity of the deep blue sea.

A control freak, yes that's me!

Needing to know

Where my feet would be.

Distress signals to my brain;

A panic I could not contain.

Travelled to far away shores,

Never the courage to explore.

Sit back and simply adore

those venturing to the ocean floor.

A summer's day came,

Little did I know

My son wanted

To give scuba a go.

The look on his face,

A sly grin,

Shaking his head,

As he's ready to dive in.

My teachings as a Momma came to me.

I'd say to my child,

"Follow your dream."

Huh! A great example I have been.

All geared up,

Cylinder and all.

His excitement contagious;

Helping my barriers to fall.

A need to save face,

Not to be my son's disgrace.

I searched for bravery,

Even a small trace.

The power of a child

Had taught me

It's never too late

To set yourself free!

Almost immediately,

A wetsuit was upon me.

A regulator, so new to me,

Only to find it's easy to breathe.

Hilarious moment for all to see!

Giggles and teasing surrounded me.

One small step is all I'd need,

Easy as one, two, three.

That was it, the moment below.

A whole new world,

I had never known.

From there on,

All systems go!!!

Immediately, an addict I would be.

Whoever would have thought

Somewhere hidden in me

That one day

A scuba diver I would

be!

Santa May Arrive

My newsfeed,

An image did appear.

Triggered a thought

Not pleasant

This time of year.

The child believing

Santa may arrive.

Is it possible,

He's not a lie?

Staring at the window,

Daring to dream.

The store full of toys;

Knowing how good

She's been.

Maybe, he'll forget

As he did last year.

I'll try harder

In the new year!

And Mummy won't cry

When she sees

Me cheer...

"Merry Christmas everyone!

Santa found me!

Even in the dark,

I'm still here!!!"

My Son

A feeling I will try to describe

But common to every mother

With a son by her side.

Stroking his back

For him to calmly wake,

After watching

His serene breathing,

Still amongst the dreams,

His night adventures

Him did take.

Turned he did,

Gently snuggled

In my arms.

Open to him

And all his charms.

From baby to young boy,

I watch him grow.

Proud, the son,

I daily get to know.

Time limit these moments have

As one day,

A lucky lady;

My son's heart,

She will capture

And smile, just as I have.

Single Dads

Often complain;

Single mums do.

Spare a thought,

For those Papas

Alone too!

Helpless, a feeling;

They try to hide.

Their goal,

Happiness,

In their kids eyes.

Work hard,

For two precious days.

'Loving', their reward

Reflected, on their child's face.

Organised – they learn to be.

No backup.

No one upon,

Whom to lean.

Exhausted – they will be.

Yet torture till,

The next time.

Their kids,

They will see.

Bedtime,

No words can describe.

Loving and tender.

Yet sadness, inevitable

With sunrise

And *'that'* inevitable goodbye...

Always Hold Their Hand

My kids are cool and are my fuel.

They are my world, my one and all.

To start the day, iPad they will play.

Ignoring anything and everything I'll say.

Before school, arguments will rule.

A guarantee, I will play the fool.

A few hours relief when they are sent away,

To the best place, to learn and play.

Teachers are saints, yet slightly insane.

Willing to sacrifice to develop a young brain.

Upon their return, all hell can break loose;

Over a trivial glass of juice.

An explosion of colour will take place;

Toys scattered to fill a vast space.

Often, home feels like a zoo.

Yet also like a blessing, no one can undo.

Berserk and bonkers I will be.

Searching for sanctuary, in my cup of tea.

"Homework" a word to cause mayhem and delay.

An array of excuses tend to come my way.

Any argument is overruled,

As I am judge and jury,

And cannot be fooled.

A prayer to the Pope, to throw me a rope.

Any glimpse of hope, on how to cope?

Warm inside, each tick and chime,

Closer to pyjamas and bedtime.

Snuggles, cuddles and soapy smells;

A priceless moment of bedtime fairytales.

Achievement, affirmation and a solemn declaration,

Of how blessed and complete I am.

To love my children; a sacred oath - to always hold their hand.

Outsmarted By A Four Year Old

My four year old repeats,

Almost everything she says.

Every wonderful thing

That's in her head.

Her thoughts run faster,

Than her vocabulary does.

Pronouncing wrongly

Yet sweetly;

She tries so hard.

It's priceless to see,

The workings of a pure mind.

Absorbing small details

That we often cast aside.

Develop each day,

With something new to say.

Searching for reason,

Yet happily pretend

She'll play.

Confirmation and agreement;

She answers

Her own questions alone.

Then, nodding her head,

Prompting mirror movement

From you, you follow unbeknown.

Only to find

Her next question

Is 'why?' You agreed

to what she said was true.

Getting outsmarted by a four year old;

It can take all day to
undo.

New Year

Christmas over.

New Year almost here;

What do you wish for?

Who will hear?

Beyond our borders

Out of reach...

Atrocities and hunger.

So many in the limelight;

Merely preach!

Maybe wars will end...

Pray, new ones don't ascend.

Enough fighting,

In the name of *'Defend'*

Reflect and hope; within

One's personal scope.

Feed your conscience,

Look deep into Life's telescope.

No one should be alone.

No luxury to postpone!

Say *'I love you'*

As hindsight may cruelly rob...

All you've wished for;

Those that made

Your heart throb.

Grateful and blessed;

Cherish all you have.

That special someone(s),

Not many can claim,

So don't be sad.

The Man, My Boy

The way you hug me;

Your gentle breath,

The way you caress,

Your face nestled in my neck.

Just as a baby;

The feeling still the same.

Yet now in public,

Your rules have changed.

You are my world;

My pride and joy.

Growing up fast;

My ten year old boy.

No water needed;

For this love to grow.

Sunshine beams

With your smile,

And you as a whole!

Enjoy, be happy;

All I need from you.

Childhood will end,

Oh, too soon.

Foundations, I see in you.

Peacefully knowing.

The man, my boy

Will turn into.

Divorce & Friends

Hard for friends, it can be.

Finding themselves,

Torn between.

Why should they choose,

Whom to lose?

But subconsciously;

That's exactly

What they do!

Divorce your partner,

Not your friends.

Is what most simply,

Don't comprehend.

Give them time,

One may say,

Or simply ignore

And go on,

Your merry way.

A chapter it may be.

Who turns the page?

... wait and see.

10 Years Old, Time For You To Know

At times we argue and I
often tell you off. You
need to know why, to
ease your anger and smile
it off.

I had injections in my
tummy that became as
black as the night. Simply to have you inside me;
snug and tight.

Vomit, is all I did, for nearly 3 months. Until my
body adjusted, to your growing legs and other
bumps.

I carried you inside me for 39 weeks - not any easy job when deprived of sleep. All I was, was fat, with swollen feet.

Temperature I had, your heartbeat beating fast. Emergency surgery, no choice, it was a must.

Cut me they did, yet I did not care. First thing I heard was your cry, but I was not scared.

Your toes, I remember, and the first kiss on your cheek. Took you away, to get you dressed, warm for you to sleep.

Losing blood after you came out, didn't know what was happening; all I cared was to have you, to love with no doubt.

Breastfed you, till I had no choice. Blood gushing, ambulance, transfusions, my multiple saviour vice.

Winter I held you, drips hanging blocking my hold. Yet I remember your smell, soft breathing, a medicine; no doctor for such a note.

Months went by, I watched you grow. Dancing with you, rocking you gently, till sleep you would behold.

Late nights; sick you would be. Your newborn cry, made sense only to me.

My body is damaged you may say, bikini took years, and still not the same.

Do I care, of what I look like? you may ask me. You're the man, I only wish to please.

You fell and cried, your broken arm, killed me inside. So, young man, please stop and wonder why… Mummy cares with anger, a look she cannot hide.

Adopt In My Arms

If there was a way;

If I could,

I would.

A child hungry;

No future.

Adopt

In my arms;

My motherhood.

Yellow, brown, black;

All the same to me.

For all that baby needs

Is a mother,

Like you and me.

Share, love and protect,

And watch her grow!

A childhood of joy,

With a smile

That will glow.

Thousands out there,

Crying and in pain.

Unable to speak,

For their mother

Has no name!

Sand Yucky And Brown

Sand and sea;

A joyful place to be.

Splashing and running,

Sandcastles built by three.

Giggles and tickles;

Mum fooling around.

Embarrassing kids;

Loving their

Objections and sounds.

Beneath it all,

Proud they are,

To see their mum

Reflecting,

Their heart star.

Carefree laughter;

Not caring,

Who's around.

Burying mum,

With sand;

Yucky and brown.

Memories created;

Their souls will keep.

Seeing the adult child

Escape, a play date

At the beach.

Appendix

Sleazy Cabarat

Trigger for me to write this poem: #examples #2008 #lehmanbrothers #cyprushaircut #2013 #2010 #greece #austerity #greed #reality #blamegame

A Voice Attached

"Freedom is not worth living if it does not connote freedom to err. It passes my comprehension how human beings, be they ever so experienced and able, can delight in depriving other human beings of that previous right."– Mahatma Mohandas K. Gandhi

A Flame to Remember

Turkish Sultan Abdul Hamid II told a reporter in 1890 in answering how he would solve the "Armenian question" once and for all. He replied (according to history.com)

"I will soon settle those Armenians,"

"I will give them a box on the ear which will make them...relinquish their revolutionary ambitions."

http://www.dailymail.co.uk/news/article-479143/The-forgotten-Holocaust-The-Armenian-massacre-inspired-Hitler.html

https://www.google.co.uk/amp/s/www.newyorker.com/news/daily-comment/remembering-the-armenian-genocide/amp

Responsible We All Are

The reason for this poem was the impact felt by the image of the 3 year old Syrian boy, Alan Kurd, who drowned on the beach.

www.ingramcontent.com/pod-product-compliance
Lightning Source LLC
Chambersburg PA
CBHW021818170526
45157CB00007B/2640